にっぽん
スズメ歳時記

写真 中野さとる

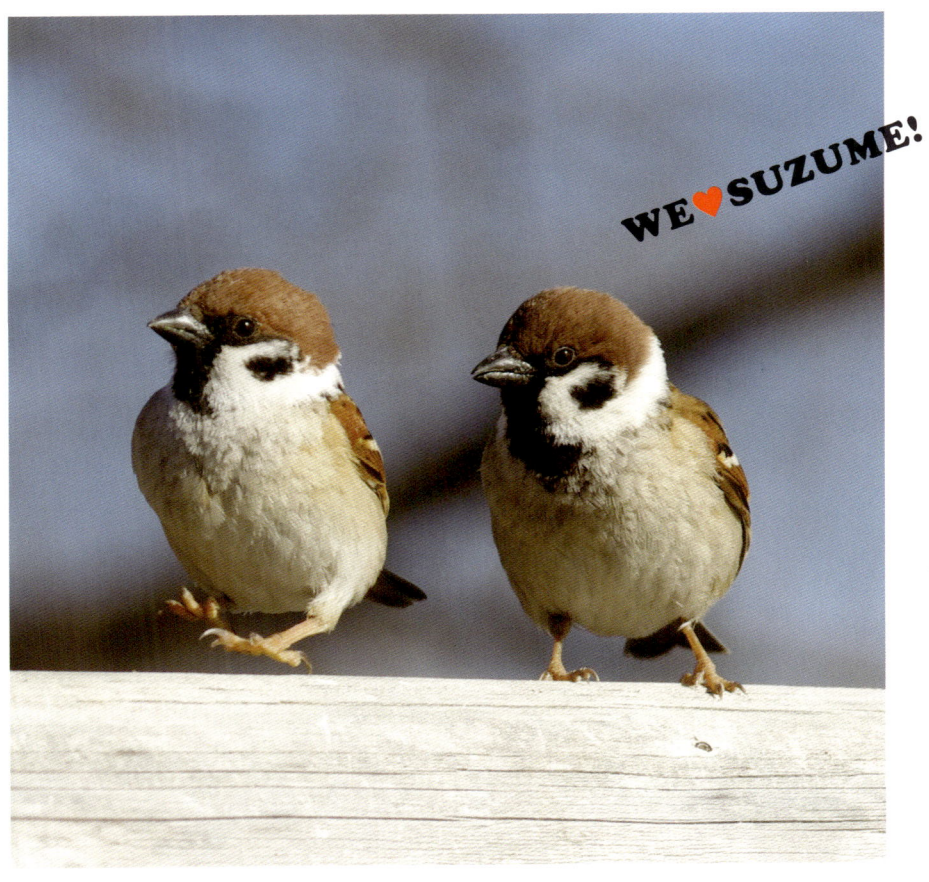

はじめに

　電線、屋根、樹木、庭、空き地、田畑──人の暮らす場所の近く、全国どこにでもいる小鳥、という印象のスズメ。身近にいる鳥を問われたら名前を挙げる人も多いでしょう。一方で、身近に感じるわりにその特徴や生態などについてはほとんど知らない、というのもまたスズメだったりします。小さく素早いため注目していても個々の動きが追いにくく、人に対する警戒心も強いスズメは、同じくよく目にするハトやカラスに比べると、そのポピュラーさに反して謎の多い野鳥の代表選手なのです。
　数年来、そんなスズメたちの日常風景を撮影し、インスタグラムを中心に発表してきたのが写真家の中野さとるさん。時にかわいくユーモラス、時に

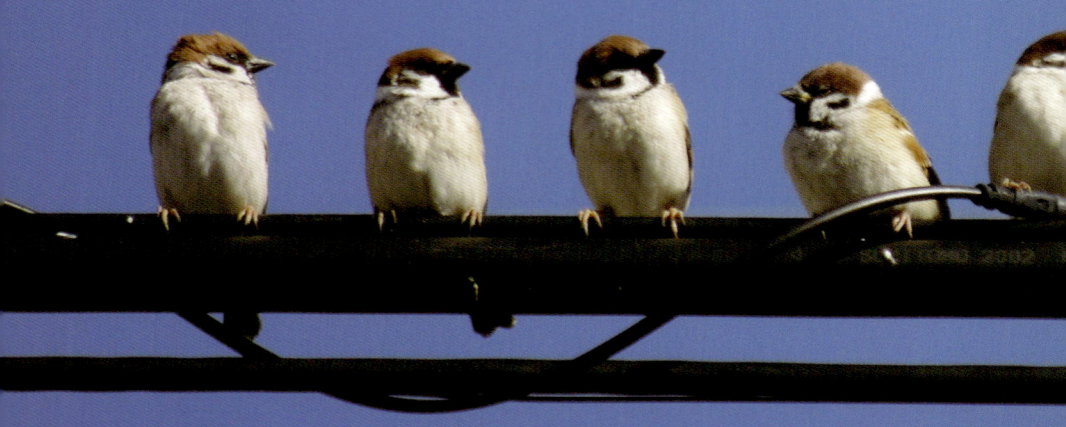

激しくワイルド、時に叙情的——中野さんが日々アップする生き生きとしたスズメたちの姿を心待ちにしている人は少なくありません。

本書ではスズメたちの表情豊かな瞬間をとらえた中野さんの写真を季節ごとにたっぷり楽しんでいただきながら、スズメの基礎知識や関連トピックス、スズメが主人公の人気マンガ『きょうのスー』作者のマツダユカさんの描きおろし作品などもご紹介していきます。

古代より日本人にとって最も近しい鳥であり続けてきたスズメ。そんな彼らの未知なる世界に触れつつ、そのバックグラウンドについても思いをめぐらす——本書をそうした機会のひとつとしていただけましたら幸いです。

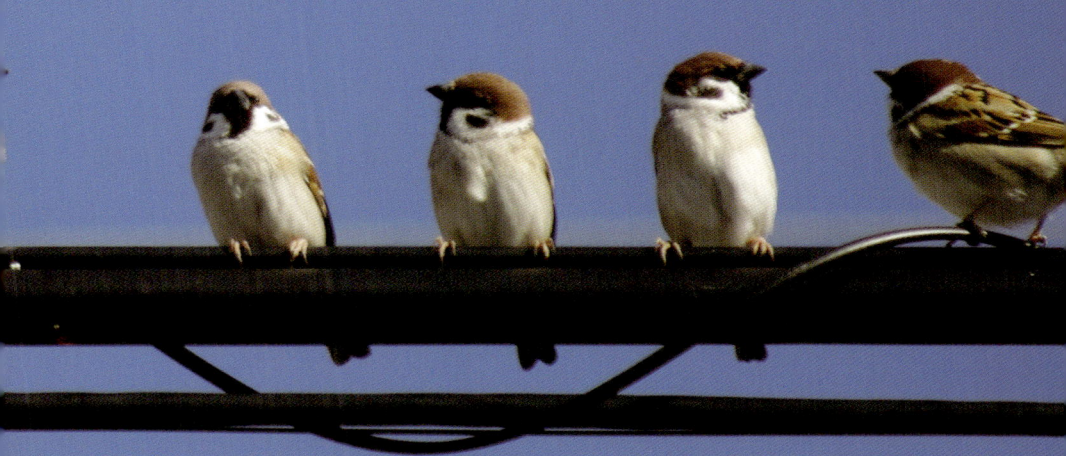

巻頭スペシャル スズメしぐさ

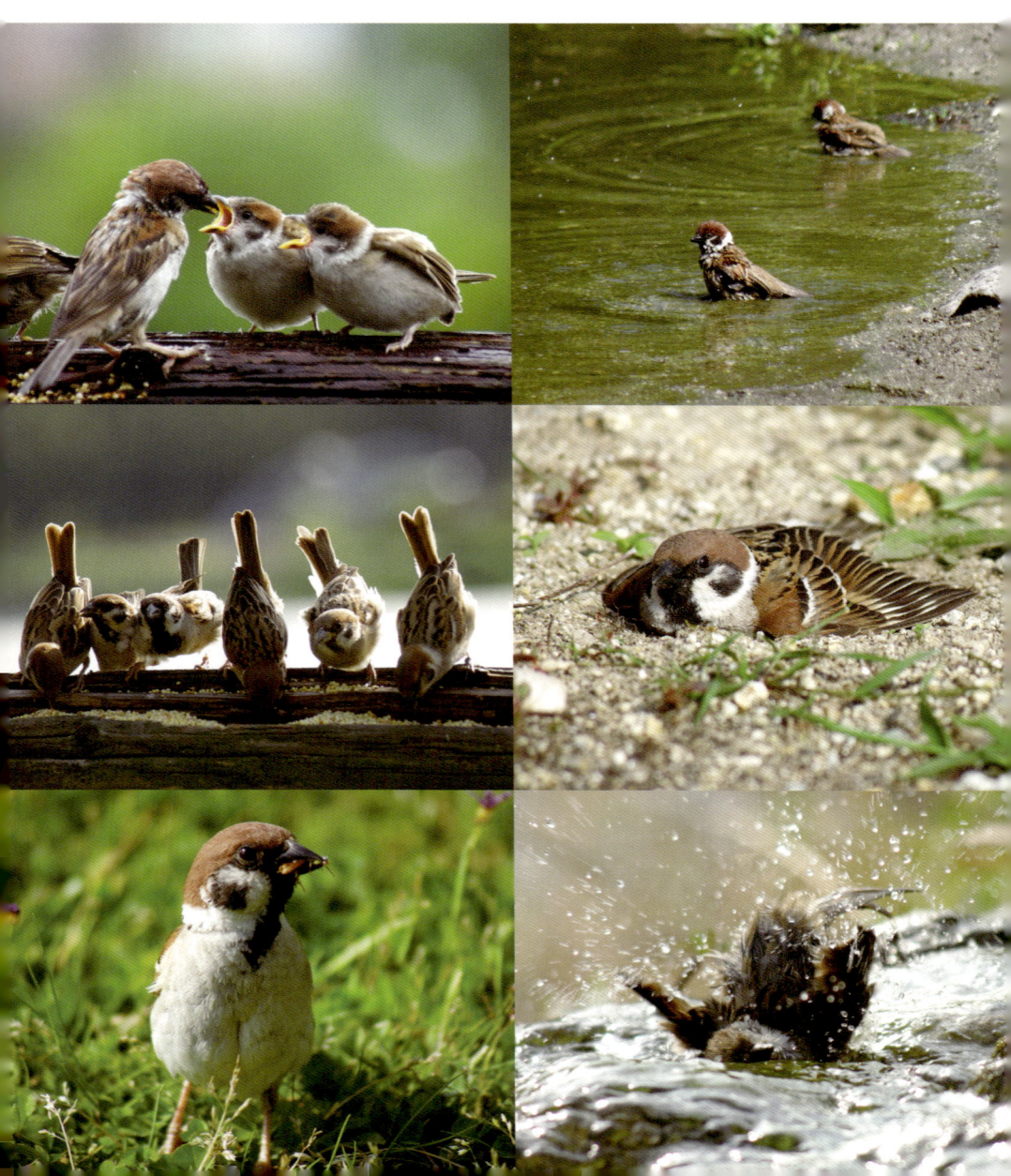

体が小さく動きが素早いスズメのしぐさは、目視することはなかなか難しいもの。食べたり飲んだり、水浴びや砂浴びをしたり、隣とやりあったり、羽づくろいをしたり。ここではスズメたちの日常的な行動の「瞬間」をクローズアップ！

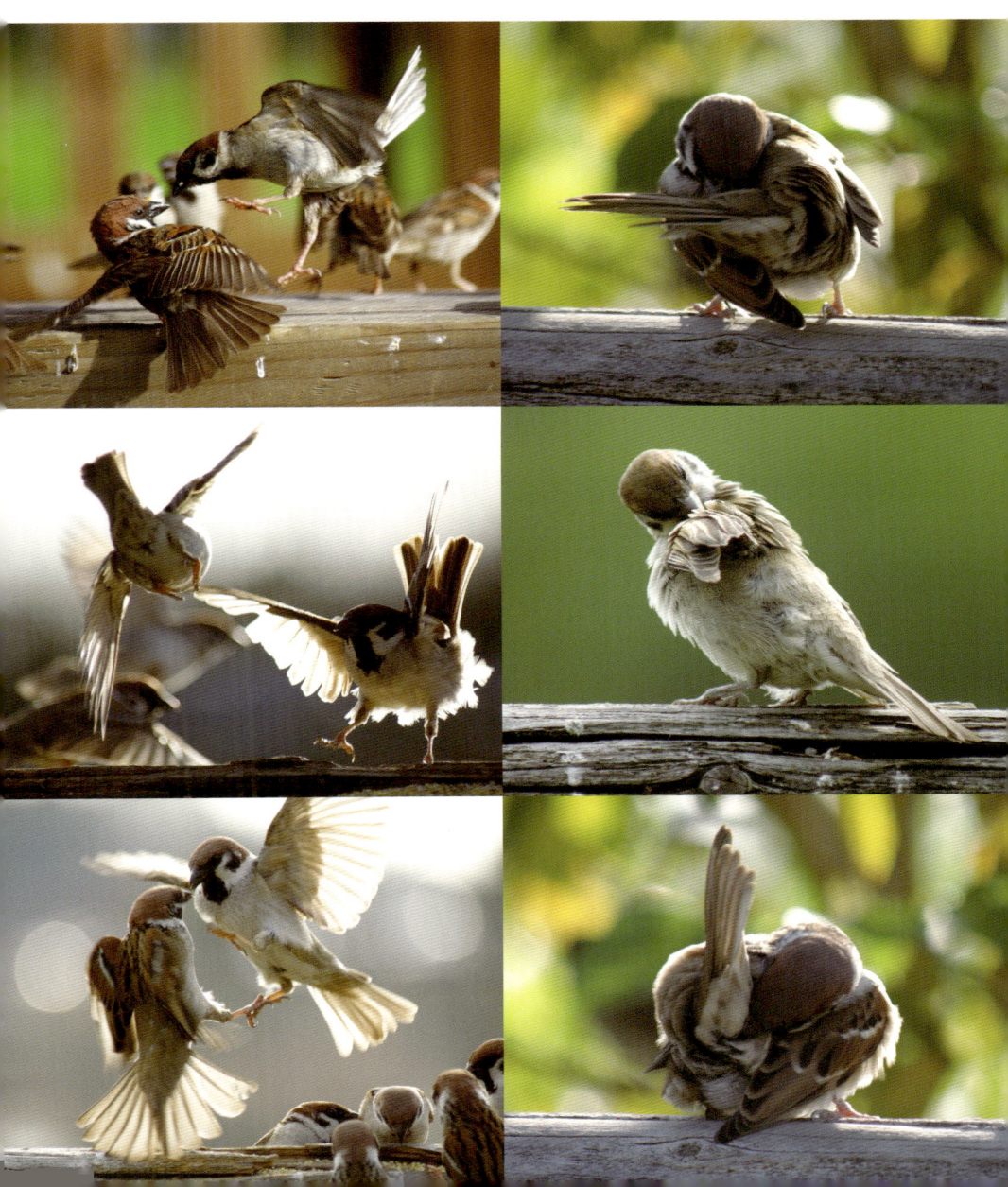

食べる・飲む

スズメしぐさ

水浴び・砂浴び

スズメしぐさ

小競り合い

スズメしぐさ

羽づくろい

スズメしぐさ

もくじ

はじめに　　2

巻頭スペシャル
スズメしぐさ　　4
食べる・飲む　　6
水浴び・砂浴び　　8
小競り合い　　10
羽づくろい　　12

WE ♥ SUZUME!
でも考えてみるとよく知らない…
スズメの基礎知識　　16
スズメってこんな鳥　　18
世界各地にいるスズメ　　20
スズメと日本人の関係　　22
スズメの一年の過ごし方　　24
スズメの子作り・子育て　　26
スズメと共存するために　　28

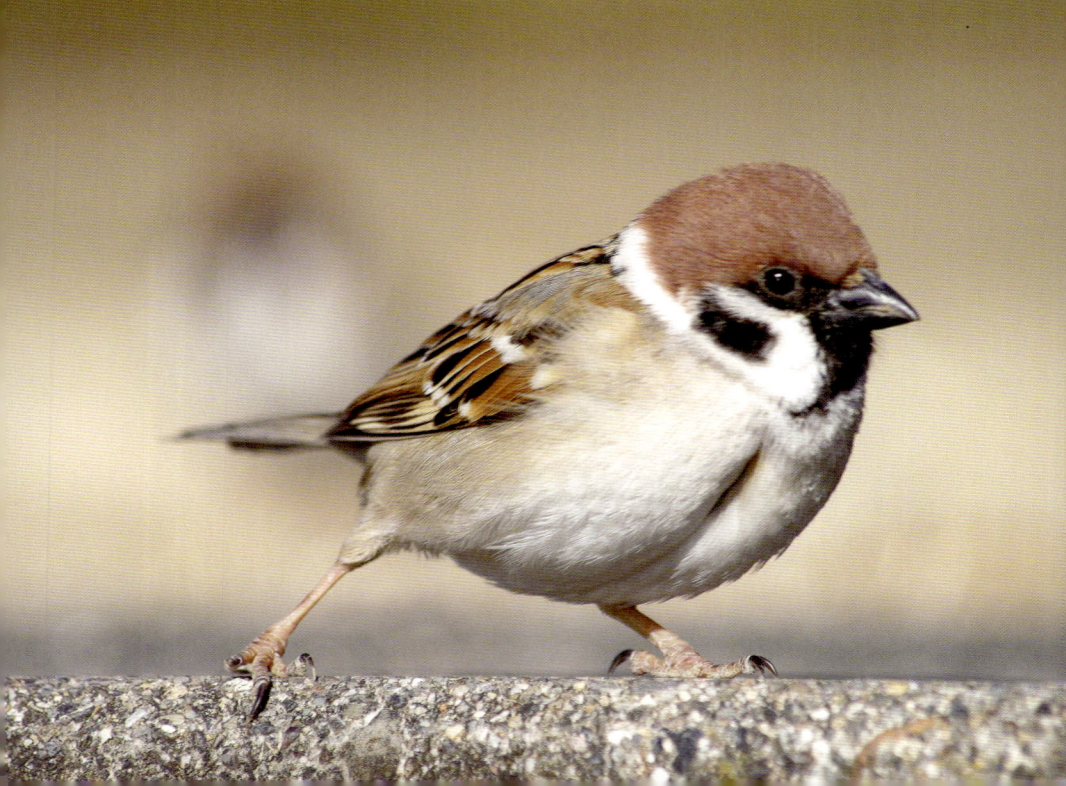

WE ♥ SUZUME! スズメの四季が見えてくる！ **にっぽんスズメ歳時記** 30	Special Interview 写真家・中野さとるさんに聞く 82
スズメの春 32	スズメにまつわる Topics & Essay
スズメの夏 46	WE ♥ SUZUME! 86
スズメの秋 58	Various Goods 86
スズメの冬 70	BOOKS & CD 89
	マツダユカ presents 「スズメかんさつものがたり」 90

※本書に掲載したスズメの写真はすべて、2013年ごろから2016年にかけて愛知県内で撮影されたものです。
※スズメの生態（行動）はその年の気候、地域など、さまざまな要素によって異なります。

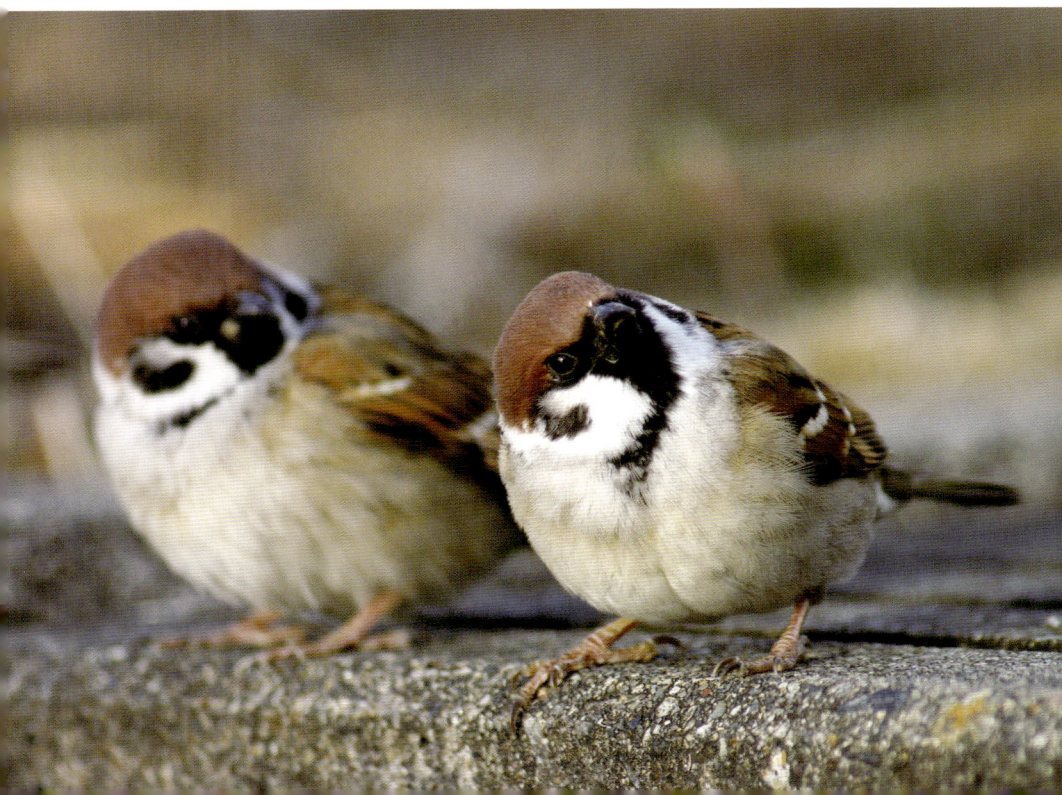

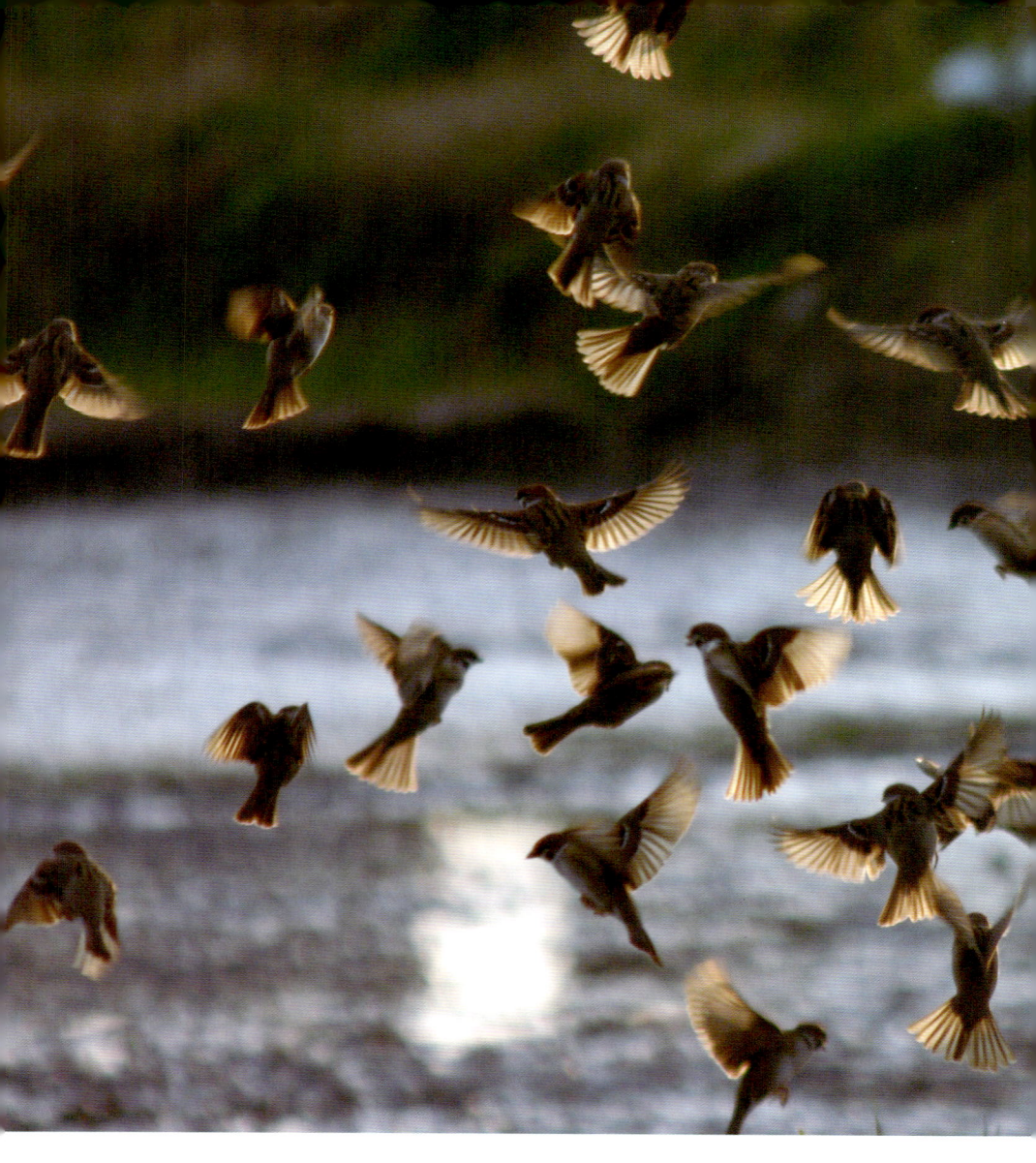

WE ♥ SUZUME！
でも考えてみるとよく知らない…

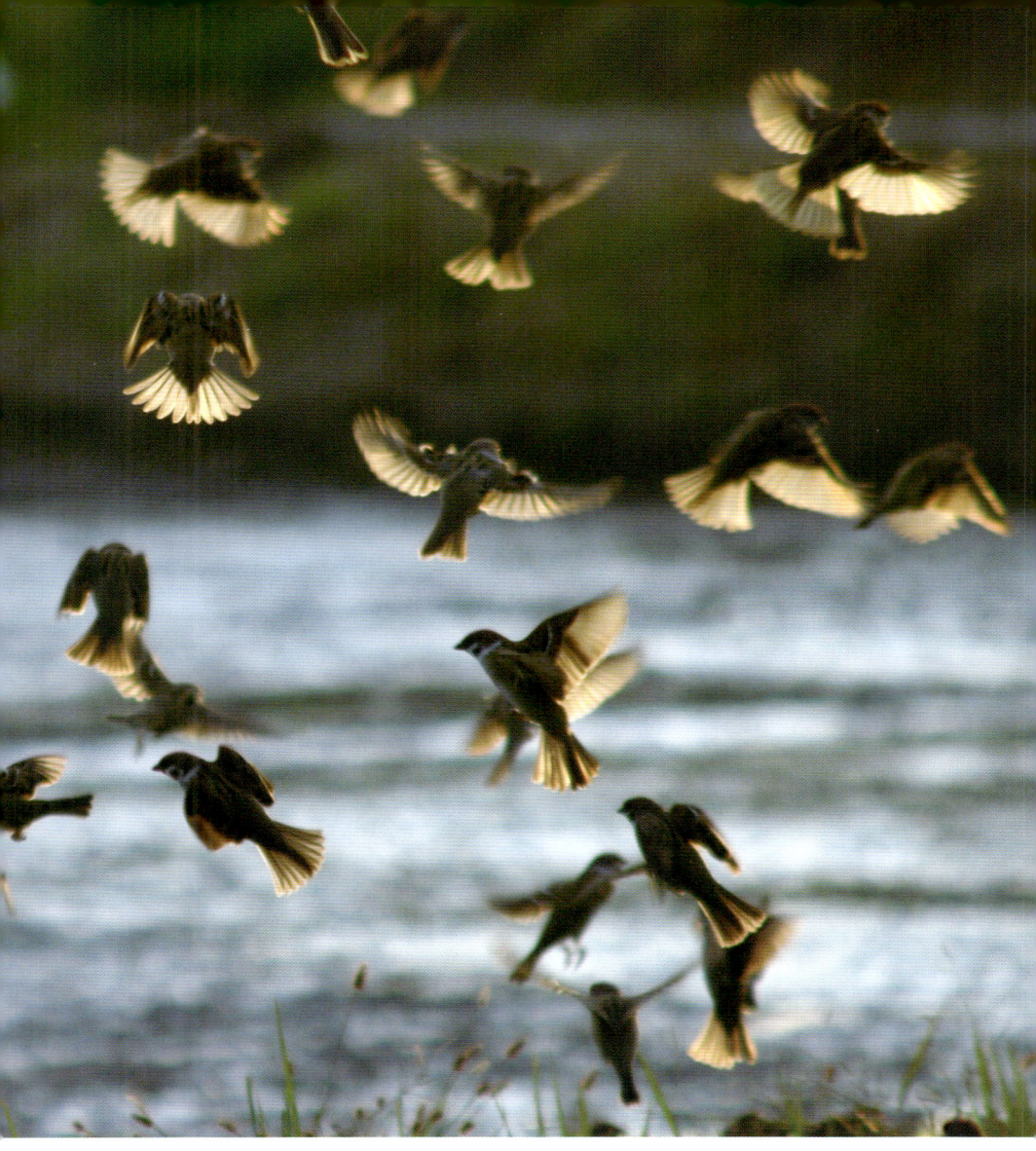

スズメの基礎知識

まずは基本のキを見ていこう
スズメってこんな鳥

スズメに限った話ではありませんが、いまだ解明できない点も多い野鳥の世界。ここでは見た目の特徴をはじめ、スズメの基本的な要素についてまず紹介していきましょう。

●体重・全長など基本の特徴

スズメは、スズメ目スズメ科スズメ属の小鳥です。日本には「里スズメ」ともいわれるスズメのほか、「山スズメ」といわれるニュウナイスズメ、まれにイエスズメがいることが確認されています。ただ、日本全国でお馴染みの種といえば、本書掲載の写真の被写体でもあるスズメ。以降でご紹介していく内容も、特に断りがなければスズメについてのものになります。

さて、そんなスズメの体重は？　体長は？　というと、答えられる人はよほどのスズメ（野鳥）マニアか、スズメに近いサイズの小鳥を飼育している人でしょう。

それ以外の方のために書いておくと、スズメの重さは、だいたい20〜25gほど。全長は図鑑などには14.5cmという表記がよく見られます。このうち尾が2〜3cmほどを占めており、翼を開いた状態（翼開長）は22.5cmくらいといわれています。

ちなみに鳥の全長は、鳥を仰向けに寝かせてくびを軽く伸ばした状態で、くちばしの先から尾の先までを測ります。しかしこの姿勢自体、自然の状態では見られないものですし、測定値は差異が出やすかったりするもの。図鑑に記された数値（調査対象の複数の個体の平均測定値）はあくまでも他の鳥と比較するための目安程度、と考えておくのが無難かもしれません。

一方で、スズメはその一般認識度の高さから、バードウォッチングの世界ではハトやカラスらと並び「ものさし鳥」と呼ばれることがあります。これは許可なく捕獲のできない野鳥の名前などを調べる際、大きさや羽の色を比較してどの鳥かを判断する基準（ものさし）となる鳥のこと。野鳥のガイドブックなどにはこの「ものさし鳥」を用いて解説しているものもあります。

●オス・メスの違いは？

体の形状や大きさ、羽の色など、オスとメスで見た目が明らかに異なる鳥は少な

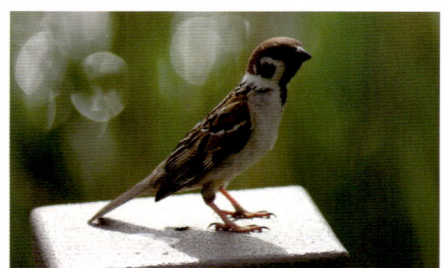

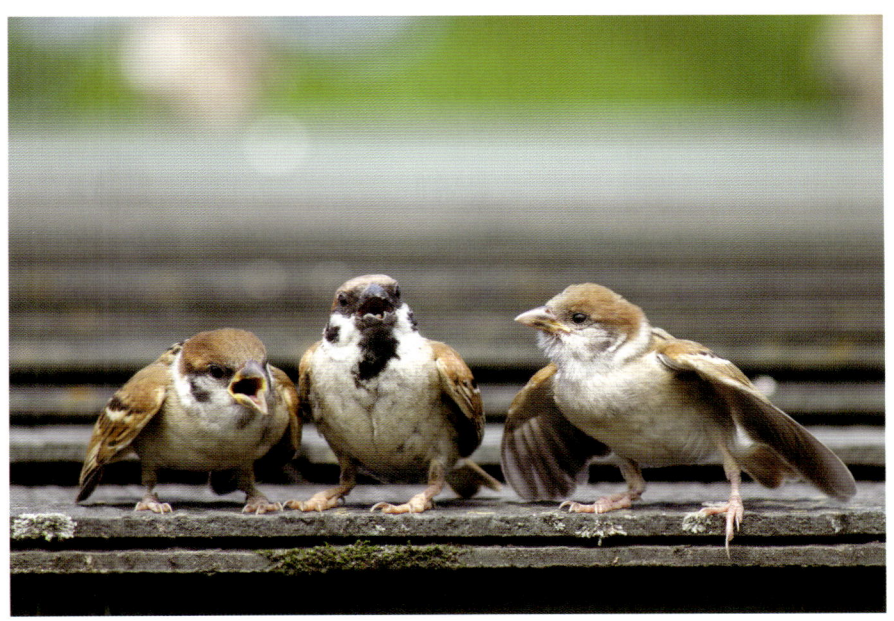

ありません。しかしスズメの場合、オスとメスの見かけに明確な違いはなし。行動も、巣の外ではオス・メスの差はあまりなく、巣作りの材料を集めたりヒナのエサをとったりと、双方がかいがいしく働きます。

ただ、交尾の際などに相手の背中の上に乗るのはオスなので、それは見分けのポイントとなります。また、求愛の際やテリトリー（縄張り）への侵入者を威嚇する際、のけぞるように上体を反らし尾を上げるポーズをとるのもオスと考えられています。

逆に、メスだけに見られる現象もあります。抱卵を前にした母鳥の腹面は卵を直接温められるよう羽毛が抜け、皮膚が露出するのです。この部位を「抱卵斑」といいます。「抱卵斑」は秋の「換羽」で新たな羽に覆われますが、お腹の真ん中にはその名残の線が。写真で観察してみてください。

●成鳥・幼鳥の見分け方

スズメの成鳥と幼鳥は、くちばしの色とのどや頬部分にある斑の色で見分けることができます。基本的には、のどや頬の斑が黒ければ成鳥です（上写真の中の個体）。

対して幼鳥は、のども頬も淡い色をしており、くちばしの根元は黄色っぽい色をしています（上写真の左右の個体）。

注意しておきたいのが、季節によってはくちばしの根元が黄色い＝幼鳥とは限らないということ。秋を迎えると、成鳥もくちばしの根元が黄色くなり、冬になるにしたがい、また黒く変わっていくのです。

季節によるこうしたくちばしの色の変化は実はほかの野鳥でも見られるもので、一般に性的アピールの意味を持っていると考えられています。

スズメの基礎知識

スズメの仲間の種類と特徴
世界各地にいるスズメ

スズメの仲間とされている鳥たちは世界各地に数多く生息しています。この項では世界におけるその分布状況などについて、日本のスズメと関連の深い種類を中心に見ていきましょう。

●スズメの仲間に共通の特徴

日本の野鳥は大きく、毎年決まった時期になると群れとなり、海を越えるなど大移動をする「渡り鳥」と、一年中ほぼ同じ地域にいる「留鳥」とに分けることができます。前者はツバメやホトトギス、ツグミ、ガン、カモ、ハクチョウ、シギなど。スズメは後者になります。そのほか、日本国内で夏と冬で住む場所を変え、渡り鳥とともに季節の使者ともいえる「漂鳥」もいます。その代表的な鳥がウグイスです。

スズメの仲間に共通の特徴としてはこの「留鳥」であること、(あくまでも他の野鳥に比べるとですが) 人のそばで暮らしたり繁殖することがある、といったことが挙げられます。

日本で繁殖も行うスズメの仲間といえば、お馴染みのスズメとニュウナイスズメです。この2種は似ていますが、ニュウナイスズメはスズメに比べて体全体が赤っぽい色をしており、スズメのチャームポイントともいえる頬の黒い斑がオスにはありません。

主に本州中部より北側の地域の林で暮らしていますが、秋冬は雪に囲まれるのを避けて移動、農耕地で群れる姿も見られます。世界的にはアジア大陸の太平洋側からインドの北部に生息しています。

このほか、日本国内でごくまれに確認されるのがイエスズメです。この鳥はロシアのサハリン州北部まで分布しており、迷った個体が日本にもやってきているのではないかと考えられています。

●西のイエスズメ、東のスズメ

スズメの仲間のうち、世界的に見て広範囲に生息しているのがこのイエスズメとスズメです。

前述のようにスズメの仲間の特徴のひとつに人の生活圏に近い場所に生息しているということがありますが、そのうち人とかなり密な関係にあるのもこの2種になります。ヨーロッパの人にとってのスズメというとイエスズメ=ハウススパロウ (House sparrow) を指すことが多く、日本のスズメはヨーロッパではツリースパロウ (Tree sparrow) と呼ばれ、その名の通り、森など少し自然の豊かな郊外に生息しています。

世界的ベストセラーとなったクレア・キップスの作品(日本版は『ある小さなスズメの記録 人を慰め、愛し、叱った、誇り高き

クラレンスの生涯』翻訳：梨木香歩、文藝春秋刊）は第二次世界大戦下のイギリスでの実話がベースとなっていますが、ここに登場するスズメはイエスズメです。

●スズメの仲間の分布状況

このほか世界には、アフリカ大陸、ユーラシア大陸を中心として、サバクスズメ、ソコトラスズメ、インダススズメ、イタリアスズメ、スペインスズメ、ペルシアスズメ、ケニアアカスズメ、ノウメンスズメ、オオスズメ、グレートスズメ、ハイガシラスズメ、ムジハイガシラスズメ、ミナミハイガシラスズメ、スワヒリハイガシラスズメ、ハシブトハイガシラスズメ、ホオグロスズメ、セアカスズメ、カーボベルデセアカスズメ、シェリーアカスズメ、クリイロスズメ、クリバネスズメ、コガネスズメ、アラビアコガネスズメ——といったバリエーションに富んだスズメの仲間たちが生息しています。

なおアメリカやオーストラリアでも一部の種が確認されていますが、これはもともと人の手で移入されたもので、自然条件下で移動、繁殖したものではありません。

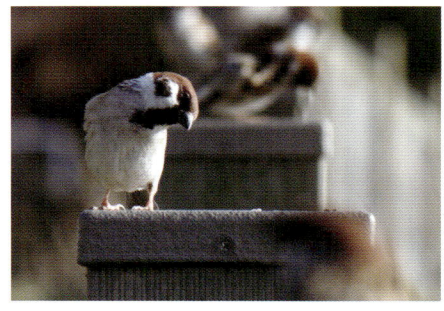

スズメの基礎知識

さまざまな文献に見るスズメ
スズメと日本人の関係

ここでは現存する各時代の文献ほかの史料に見られるスズメに関するあれこれをご紹介。日本人にとってスズメが身近な存在であり続けてきたことが再確認できるはずです。

●スズメが登場する最古の文献

古来、日本人にとってごく身近な存在として親しまれてきたスズメ。その名は「スズ」と「メ」の2つの言葉が合わさったものといわれています。由来にはいくつか説があり、『雅言音声考』では「シュシュ（鳴声）と、メ（群）から」とされているほか、「スズ」は小さいことを表す「ササ（細小）」から、「メ」は鳥を指す接尾語（例：ツバ「メ」、カモ「メ」）、といった説もあります。

そんなスズメの名が文献に初めて登場するのは、8世紀に編まれた日本最古の歴史書とされる『古事記』。天若日子の葬式のシーンで確認できる「雀為碓女」（米をつく役目＝「碓女」のスズメ）がそれです。

同じく8世紀、720年に完成したとされる伝存する最古の正史『日本書紀』にもスズメに関する表記は見られます。当時の有力権力者であった物部氏と蘇我氏の対立を決定的にしたエピソードとして、物部守屋が蘇我馬子を「如中猟箭之雀鳥焉」（大きな矢で射られた雀のようだ）と評したと記されているのです。

●神聖視された白いスズメ

また、白いスズメがおめでたいことの起こる前兆（吉兆）とされる鳥＝「瑞鳥」として天皇をはじめ高貴な人々に献上されたという記録も。白蛇などと同じく白いスズメは神聖視されていたようです。その発生確率などは不明ですが、ただでさえ生存率の低い野鳥の世界において、通常より目立つ色

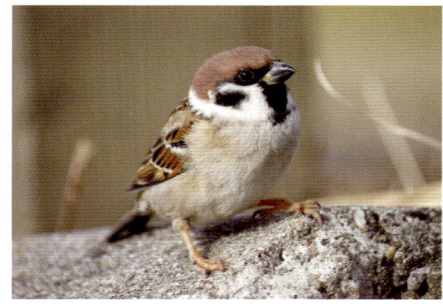
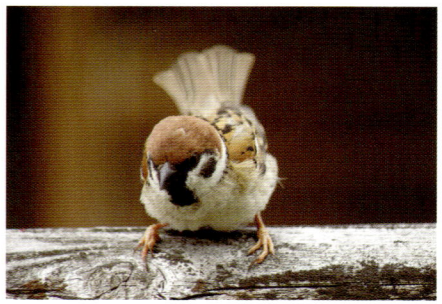

のスズメは生き残る上では大きなハンデとなり、もともと健康面で何かしら問題を抱えている確率も高いであろうことを考えても冬を越して生きのびた個体はさらに珍しい（ほとんど冬は越せないのでは）という意見もあります。その希少さが「瑞鳥」の考えにつながったのかもしれません。

●スズメが登場する中世の文献

中世になると、貴族らの後援を得て随筆や小説といった文学作品が発展しますが、ここにもスズメは数多く登場します。清少納言の記した『枕草子』では「心ときめきするもの。雀の子飼ひ。」のほか、数カ所でスズメについて言及されており、当時の貴族階級の人々がスズメをどう見ていたかを清少納言の筆を通してうかがい知ることができます。また、紫式部『源氏物語』の光源氏と幼少時代の紫上の出会いの場面が描かれた「若紫」の章にある「すずめの子を犬君が逃がしつる。」という一節も非常に有名。『枕草子』の記述と合わせ、スズメの飼育が貴族の子女の間に定着していたことがわかります。

文献以外では、正倉院に収蔵された宝物にスズメに縁のものが複数認められるほか、鎌倉以降はスズメがデザインされた複数の家紋が用いられるようになりました。富と繁栄の願いをこめ、「福良雀」「福来雀」など縁起のよい文字を当てる「ふくら雀（脹雀）」もそのひとつです。ちなみに左ページ右下写真のスズメのポーズは、尾の部分などかなり「ふくら雀」を彷彿とさせるものとなっていますね。

●俳句に歌われたスズメ

時代が下がって江戸の町でもスズメは広く親しまれていました。入手しやすく飼いやすいスズメはペットとして人気を博し、葛飾北斎がおとぎ話の「舌切すずめ」をモチーフに、歌川広重が『名所江戸百景』にスズメをそれぞれ描いたり、スズメの頭を思わせる雀茶という色も流行しました。また、スズメにまつわる季語も多く作られ、多くの文人がスズメを句に詠みました。そのいくつかを挙げておきましょう。

春の季語…「雀の子」「親雀」「雀の巣」「孕雀」「春の雀」
夏の季語…「雀のたご」
秋の季語…「稲雀」「雀蛤となる」「入内雀」
冬の季語…「寒雀」、新年の季語…「初雀」
四季の季語…「群雀」

稲雀　茶の木畠や　逃げ処
　　　　　　　　　　　　松尾芭蕉
夕立や　草葉をつかむ　むら雀
　　　　　　　　　　　　与謝蕪村
われと来て　遊べや　親のない雀
　　　　　　　　　　　　小林一茶
雀子や　走りなれたる　鬼瓦
　　　　　　　　　　　　内藤鳴雪
いそがしや　昼飯頃の　親雀
　　　　　　　　　　　　正岡子規
藁さがる　けふは二すじ　雀の巣
　　　　　　　　　　　　高浜虚子
某は案山子にて候　雀どの
　　　　　　　　　　　　夏目漱石

その行動サイクルをチェック！
スズメの一年の過ごし方

この項ではスズメたちが一日、一年をどのように過ごしているのか、巣作りや子育て、越冬など、その行動を季節に沿ってご紹介。自然界を生き抜く姿が見えてきます。

●スズメの日常的な行動

　自然の中で生きるスズメは、毎年ほぼ同じ流れで一年を過ごします。つまり、春から夏にかけて生まれ、親鳥からエサをもらいながら2～3週間を過ごして巣立ち、秋には「換羽」を行って来るべき冬に備え、春を前にパートナーを探して巣作り、続いて子作り、子育てを行っていくわけです。

　ちなみに「換羽」とは羽が新しく入れ替わることで、スズメは年一度、秋に行います。羽は鳥たちにとって自らの命を左右するほど重要なものですが、「換羽」までそれを維持するため、どの鳥もこまめに手入れをしています。スズメを注意深く観察していると、後ろを向いて腰のあたり、ちょうど尾羽の付け根の部分をつついていることがあります。そこには蝋状の物質を出す腺があり、それをくちばしで羽に塗ると、しなやかさと強靭さ、保湿性を保つことができるのです。また、寄生虫がつくのを防ぐことにも役立つと考えられています。

　寄生虫といえば、スズメたちはその予防と除去などのため、水浴びや砂浴びを頻繁に行います。本書巻頭の「スズメしぐさ」などにもせっせと水浴びや砂浴びに勤しむスズメたちの姿を収録しているのでチェックしてみてください。

　そのほか、日常的に行うスズメの大切な仕事といえば、エサとり。子育て中であればなおさらです。エサの内容は季節や地域によって異なりますが、大きく昆虫と植物に二分され、子育ての時期に親鳥がヒナに与えるエサは、主に昆虫になります。種類としては、バッタや蛾、アブラムシの仲間など。一方、実りの秋から冬にかけてはスズメのエサは植物＝穀類や雑草の実(種子)が増えていきます。

●一生にほぼ一度の大移動

　ほかの多くの鳥類にも見られることですが、スズメの幼鳥の多くは巣立ち後、生まれた地域を離れ、別の土地に向かう旅に出て、しかるべき土地に居つきます。この際の移動距離は個体によってまちまちながら、「留鳥」であるスズメが一生に経験する中ではおそらく最長、かなりの距離の移動であることは確かです。

　移動した先で定着した幼鳥は、2年目以降は基本的にその地でつがいとなり、子育てをします。親スズメとなったこの2年目以

降は、生まれた年のように移動することはせず、多くがその地域に居つくと見られています。そして、自分の巣場所を防衛しつつ、次の繁殖期を迎えるのです。

ただ、寒い地域で繁殖をした親スズメのごく一部は、秋ごろになると暖かい地域、あるいはエサが安定して得られる地域へと移動することも。これは危険が伴う上、一生懸命作った巣をほかの鳥に奪われてしまうリスクも高い行動ですが、寒さや飢えを避けるためにはやむを得ないという判断なのでしょう。

さて、前述のように一生にほぼ一度の移動をし、ある地域に居ついたスズメたち。10月〜11月ごろには、彼らのうちある程度の数が町を離れ、地域内の田畑のある農村へと移動します。そこで時には千羽、万羽単位にもなる大きな群れを形成し、豊かに実ったコメなどを食べ、越冬のための体作りをするのです。

●カップルとなり巣作りを開始

食べ物も少ない、寒く厳しい冬を乗り越えたスズメが本格的なつがい形成と巣場所の確保をはじめるのは、毎年2月ごろ。このころのスズメたちは血気盛んで、巣の場所やメスをめぐっての取っ組み合いのケンカも少なくありません。

そうした時期を経て無事カップルとなった2羽は、桜が咲くひと月ほど前からいよいよ巣作りに向かいます。

スズメが巣場所として好むのは、住宅や道路標識、電柱に付いているさまざまなパーツなど人間が作った構造物の隙間。木のほらや主のいないツバメの巣を利用したりもします。

巣は主に植物の草などを編んで作ります。春先、巣の材料にする枯れ草をくわえてせっせと運ぶ、左下写真のようなスズメの姿を目にしたことがある人もいるのでは?

形状は巣場所によっても異なりますが、たいてい天井のある球状に近いもの。ただし屋根瓦の下の隙間に作られる巣は瓦が天井代わりになるので、それを活かした形になっています。

スズメに限らず、鳥の巣というのは、基本的に抱卵しヒナを育てるための場所です。抱卵期の親鳥は昼夜を問わず卵を温めるため、その間巣は寝床にもなりますが、その後、ヒナがある程度大きくなると、親鳥は巣の近くの木立の中などで休みます。

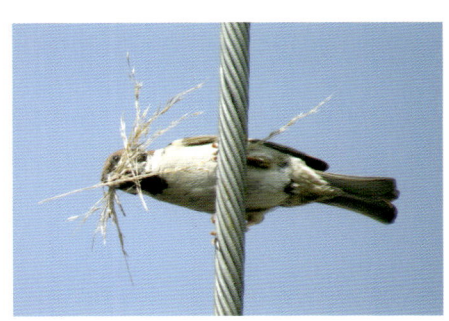
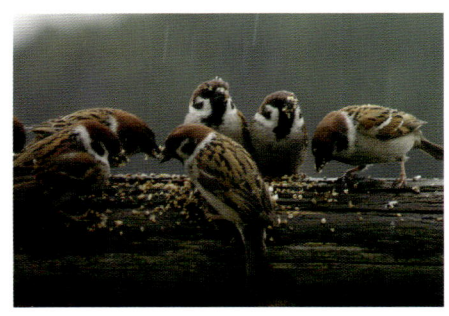

スズメの基礎知識

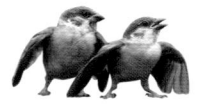

親鳥の子育ては至れり尽くせり

スズメの子作り・子育て

スズメは子作りはもちろん、巣作り、子育てのほとんどを夫婦で行います。その熱心さは人間が恥ずかしくなるほど。知ればスズメを見かけるたびに応援したくなるでしょう。

●巣作りと並行して子作り

　夫婦で協力して巣作りをするスズメは、巣の完成前後、4月を過ぎたころから、屋根の上、公園のベンチや路肩など、場所を選ばず交尾に励むようになります。その際、オスは交尾のときだけ聞くことのできる、細い特徴的な声を出すといわれています。

　交尾の際、オスはメスの背中に乗っては1秒もせずにさっと降り、また上に乗るという動作を数度繰り返します。受精はオスのスズメがメスの背中に乗り、総排泄孔という部位を密着させて精子を送り込むことで行われますが、複数回メスの上に乗るオスがそのたびに受精にのぞんでいるわけではなく、背中に乗っているだけということも。多くの場合、最後に乗ったときの時間が長いので、それがいわゆる本番なのではと考えられています。ではそこに至る行動はなにかというと、タイミングを計るため、メスを慣れさせリラックスさせるため、など諸説ありますが、ほかの多くのこと同様、真相のほどはわかりません。

　なお本書にもメスの背中にすました顔つきで乗るオスの姿をとらえた写真を掲載していますので探してみてください。

●卵を抱くのは全員まとめて

　無事受精が果たされると、地域により多少時期の変動はありますが、桜が咲くころからメスは卵を産みはじめます。

　その大きさは14～20mm程度で、一日1卵、合計で4～6個。すべての卵を産み終わると、ここでようやく母鳥は抱卵をスタートします。

　最初の卵を産んでもなかなか抱卵しないのは、卵の発育は温めはじめるまで停止状態にあるため。すぐに抱卵をはじめてしまうと先に産んだ卵からかえったヒナがほかの卵をつぶしてしまうかもしれませんし、また、先にかえった体が大きいヒナと遅れてかえった小さなヒナが一緒だと後者はエサをうまくもらえなくなってしまうかもしれません。それを避けるため、すべての卵を産み終えてから卵を温めはじめることで、だいたい同じ日にヒナがかえるようにしているのです。孵化にかかる日数は、およそ2週間弱といわれます。

　18ページのオス・メスの違いのところでも触れましたが、卵を温める前の母鳥の体には抱卵斑ができ、これにより皮膚で直接、卵を温められるようになります。これはほと

んどの鳥類に見られる現象です。

●子育て期間の親の仕事

母鳥が抱卵しはじめてからその卵が孵化し、ヒナが巣立つまで2〜3週間。つまり、産卵から巣立ちまでの期間はひと月強です。

ヒナがエサを求めて鳴きはじめる声が巣の外にも聞こえるようになるのは、孵化してから5日目くらい。声が聞こえるようになったら、その後10日くらい先が巣立ちだろうと予測することができます。

孵化したばかりのヒナは無毛で2gほどで、その後親の献身的な世話により、羽も生えそろい2週間ほどで20gに達します。

そしてしかるべき時期になると、親鳥は巣立ちを促すため、エサ運びをやめます。

困ったヒナはエサを求めて巣立つのですが、実はその後もしばらくヒナは親鳥と一緒にいることができます。この間にうまくエサをとれない幼鳥は親から食べ物をもらったり、何が危険かを教えてもらったりするのです。

スズメの子育ては最後まで至れり尽くせり。それを多いカップルでは年に2〜3回行います。

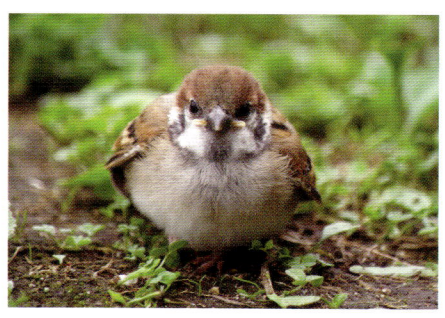

スズメの基礎知識 27

「よかれ」と思う気持ちが……
スズメと共存するために

身近な自然の多様性を守る姿勢は大切ですが、人がどう関わるかというのは非常に難しい問題。最後に、スズメをはじめ野鳥に向かい合う際の注意点などについて触れておきます。

●スズメは飼えない？

スズメを飼ってはいけない、と聞いたことがある人も多いのではないでしょうか。実際、スズメの野鳥としての生を尊重するという意味で、家で飼うために捕獲することは法律により禁止されています。

一方で、一般家庭でもスズメを飼っているというケースは確かに見られます。多くが「保護飼育」といわれるものです。

事故や病気などが原因で自らの力だけでは生きていけない野生鳥獣を保護して育てる必要がある場合、各自治体の担当部署に届け、許可が下りると「飼育許可証」（毎年更新する義務がある）が発行され、保護飼育が可能となるのです。

ただ、飼育許可証は申請すれば取得できるというものではありません。近年は保護対象と考えられる野生鳥獣を保護しようとする人にも許可が下りにくくなっています。

●「保護飼育」の落とし穴

それはなぜなのか、理由は特定できませんが、ひとつには、保護保育が違法飼育の隠れみのにならないようにするため、といった配慮などが考えられます。

もうひとつには、間違った保護があります。スズメに限らず、巣立ち直後の野鳥のヒナは迷子のように思えることが一見少なくありません。そのままにしておけば自然の中で育っていたと思われるそれらのヒナを、間違って保護してしまう人がとても多いのです。

たとえ本当に病気やけがであったとしても、自然環境下で生き抜けないか否かは専門家でも判断の難しいところ。病気やけがが完治した後は自然に帰すことが前提ではあっても、一説には人が育てることによって起こる栄養や運動の不足がもとで野生に戻れなくなるケースも多いのだとか。保護＝野生鳥獣のため、という思いが結果的に裏目に出ないとも限りません。くれぐれも慎

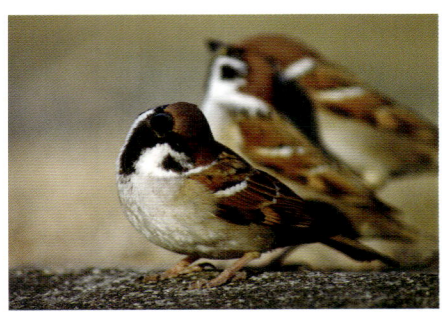

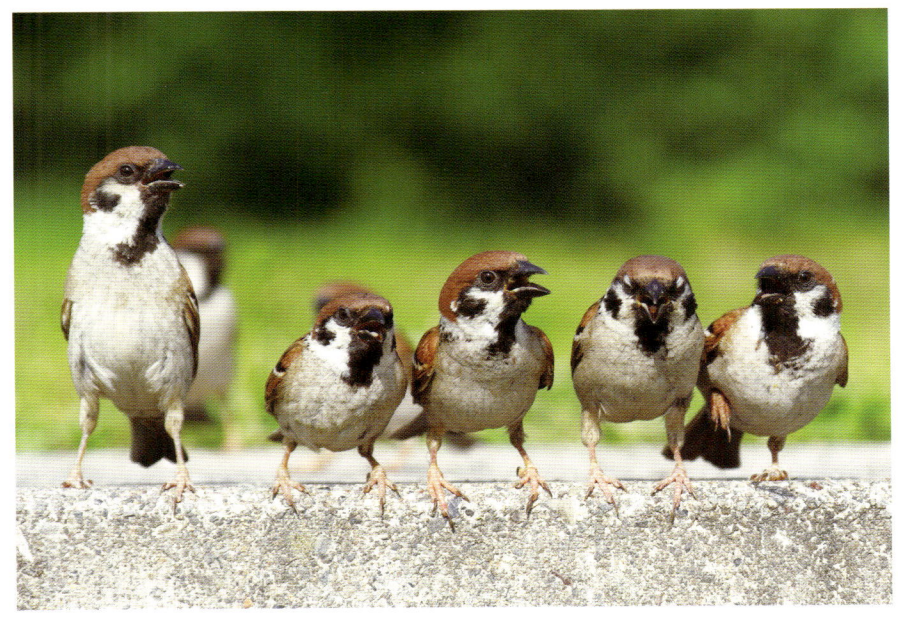

重に、冷静な判断を心がけたいものです。

　四半世紀以上前、2000年を前にしたイギリスで、日本のスズメのような存在であったイエスズメの姿が消えていることが問題視されるようになりました。その理由は複合的なものとしかいえませんが、身近な自然の多様性が失われていることは日本も同じ。留意すべき問題といえます。

●野鳥のヒナ拾うべからず

　公益財団法人日本野鳥の会では、1995年から「野鳥の子そだて応援（ヒナを拾わないで）キャンペーン」を行っています。これは、スズメをはじめとする野鳥が子育てをする春から初夏にかけての季節に、"心ある"人たちの勘違いによりヒナが不必要な保護（誤認保護）をされてしまうのを防ぐための活動です。人間の知識不足による行動の多くが、実は親鳥とヒナを引き離し、ヒナの命を縮めることにつながっている、その悲劇を避けるための情報発信です。

　より具体的な知識を得られるツールとして、日本野鳥の会では『ヒナとの関わり方がわかるハンドブック』を提供しています（公式サイトhttp://www.wbsj.org/ でダウンロードも可能）。ヒナの状態（じっとしていて動かない／けがをしている／カラスなどにおそわれそうになっている／元気そうだが単体でいる）ごとにとるべき対処法を紹介しているほか、身近な野鳥の子育てデータ、メジロを例にとったヒナの成長段階の紹介など、野鳥のヒナはもちろん自然や野生動物との関わり方を考えるためにも有効です。家族で、友人同士で、ぜひ一読してみてください。

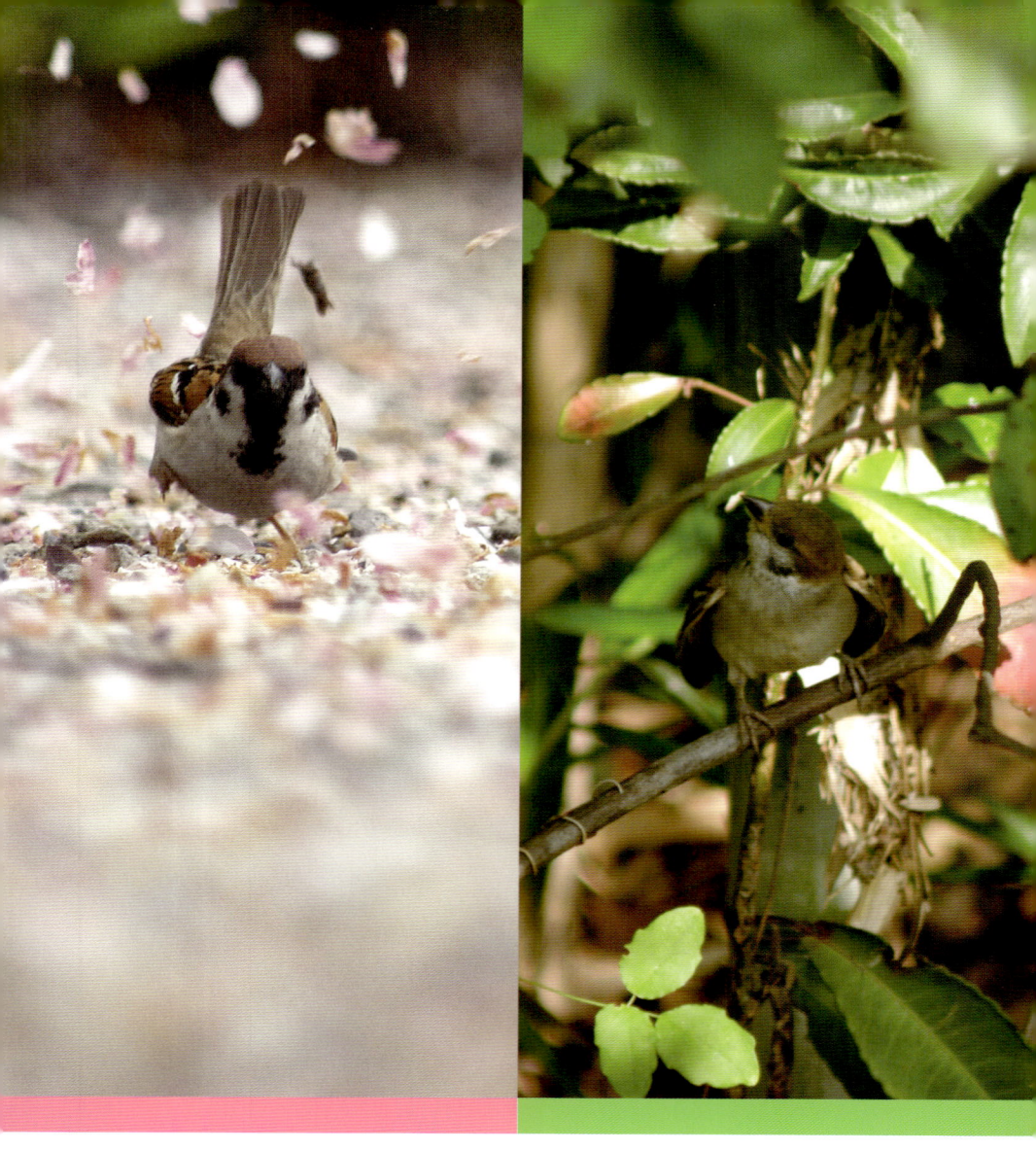

WE ♥ SUZUME！
スズメの四季が見えてくる！

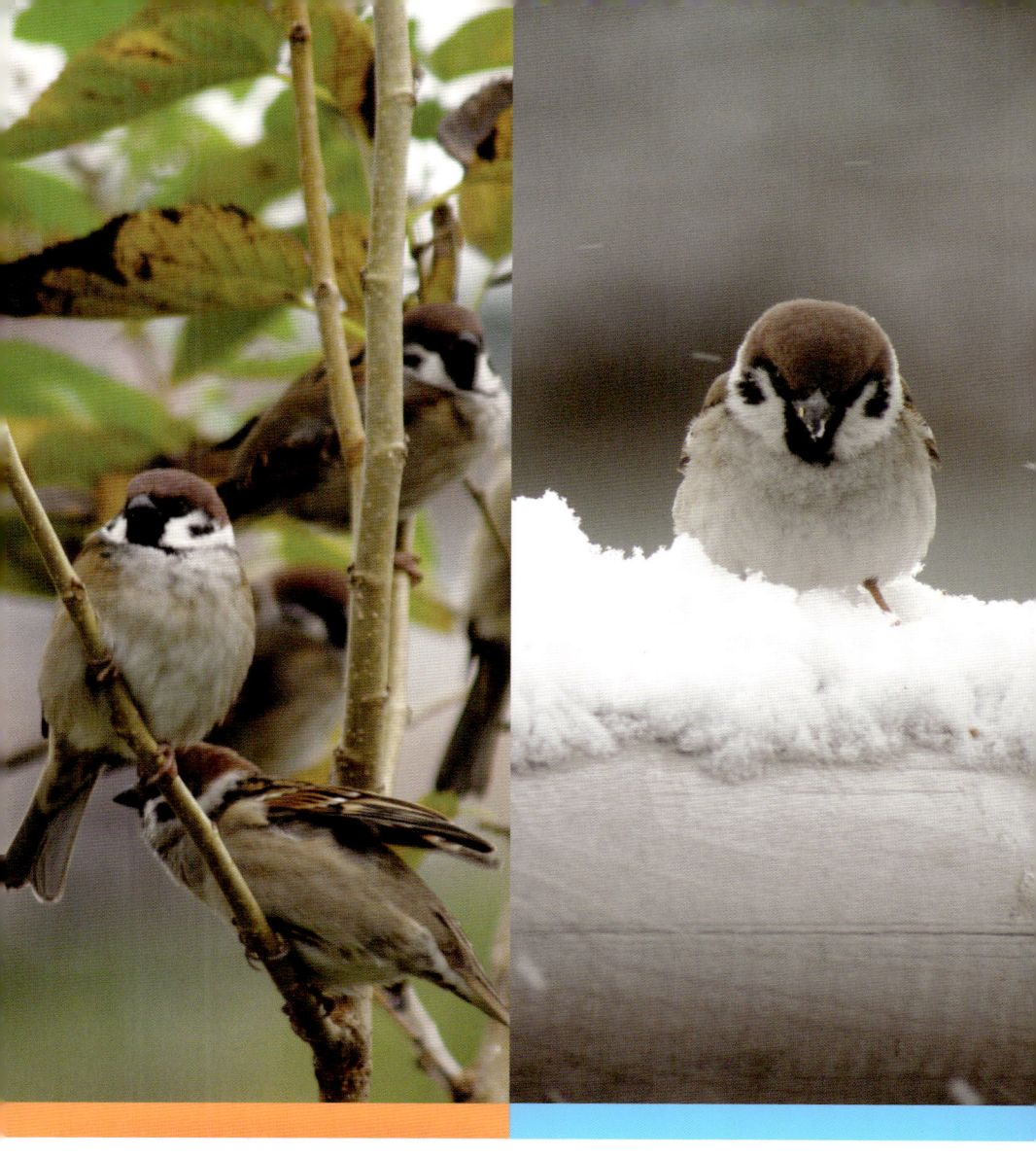

にっぽんスズメ歳時記

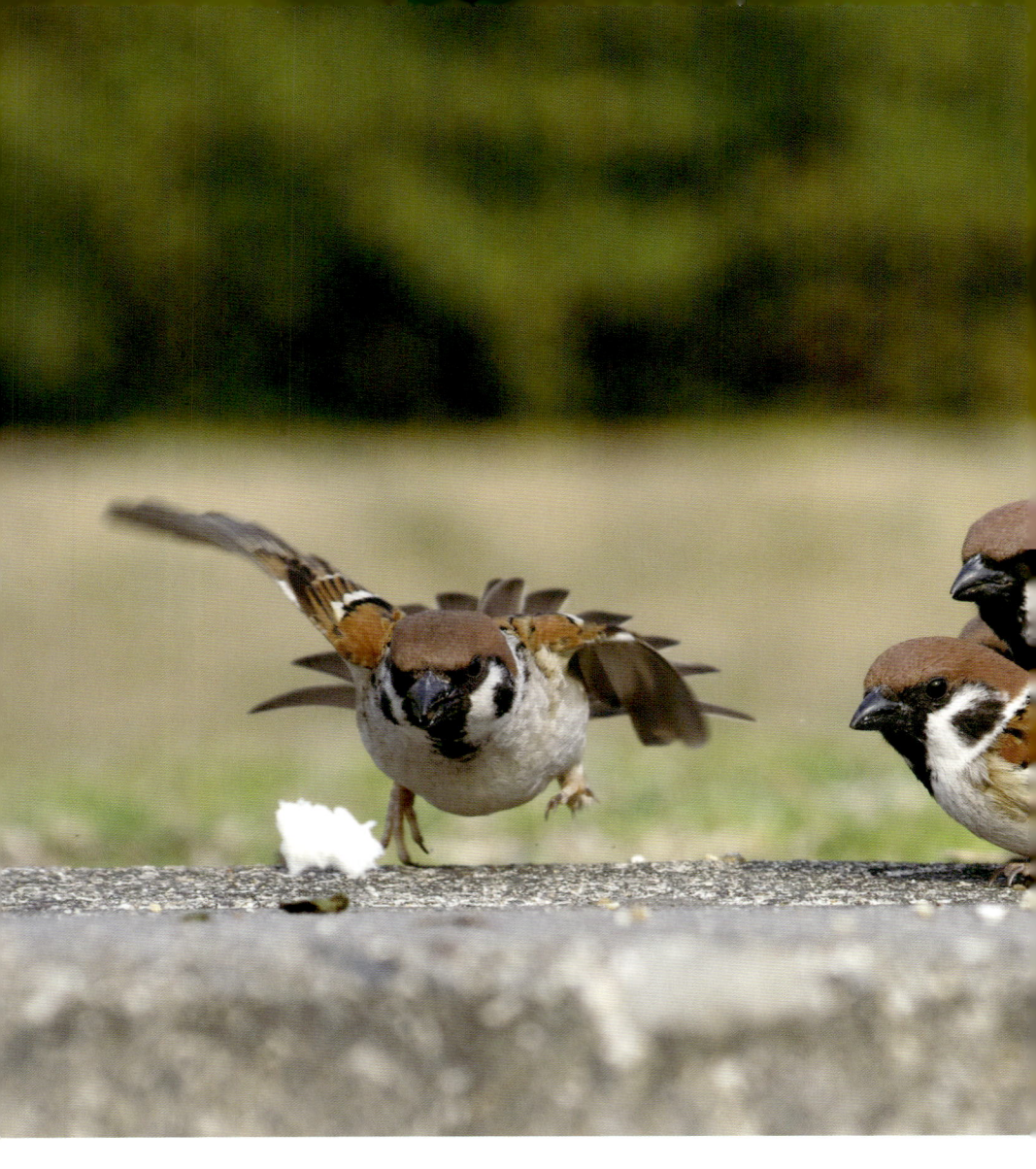

スズメの春

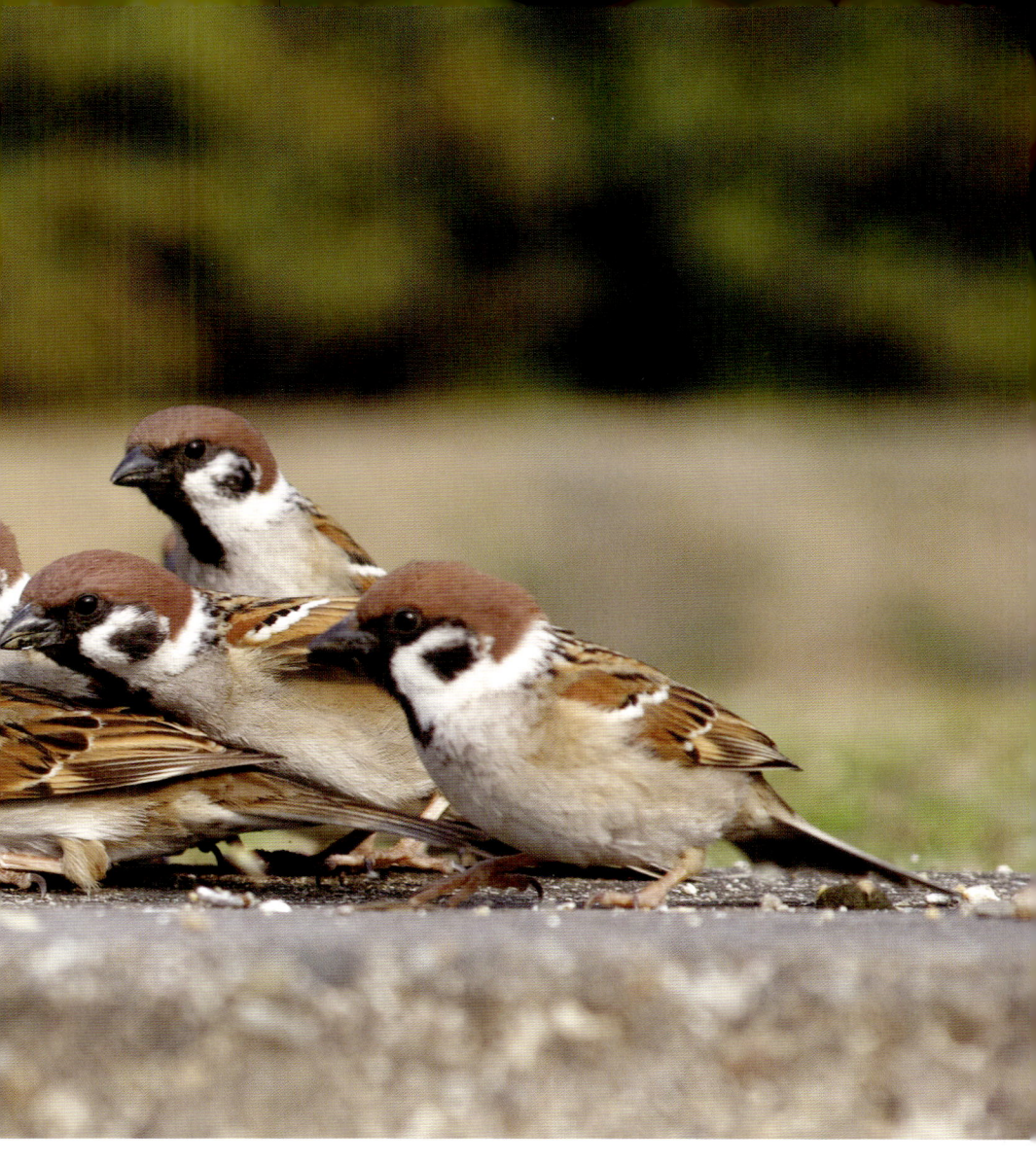

3月上旬ごろまでは余寒と呼ばれる冬の寒さが残る地域はあるものの、中旬からはほとんどの地域で初春の暖かさに。樹木に新芽が萌え始めると、スズメたちも次世代を育む季節です。ここでは3・4・5月のスズメたちの様子をご紹介します。

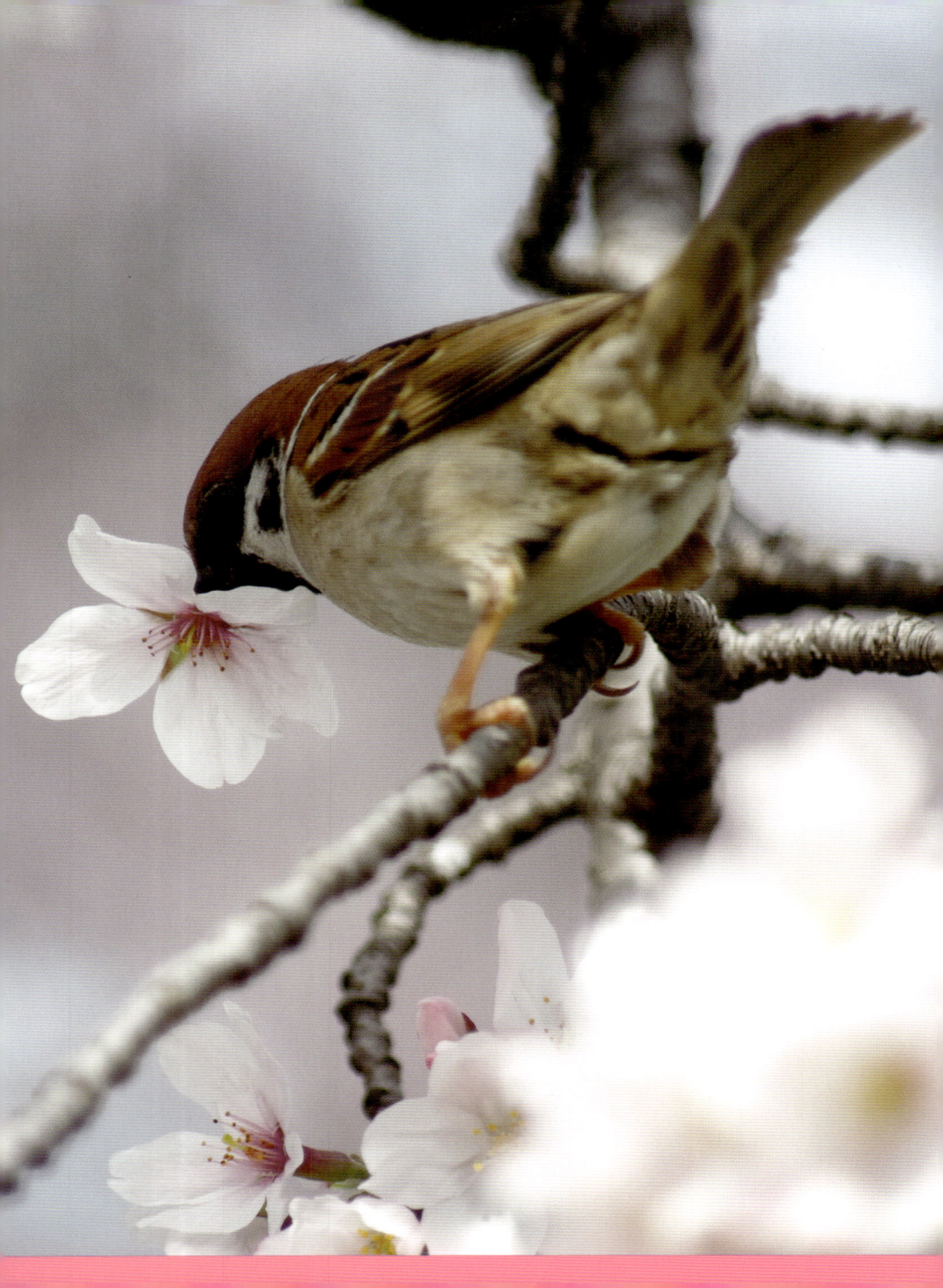

日本の春を象徴するものといえば、国花のひとつでもある桜。3月後半ごろ、桜前線は南日本からスタートし日本列島を徐々に北上しますが、この季節に桜の木の下で花びらとともによく目にするのが、地面に丸ごと落ちている桜の花です。実はこれ、多くがスズメのしわざ。スズメが花ごとちぎって蜜を吸っているのです。花粉をくちばしなどにつけ受粉の媒介者となることもなくただ蜜を吸うだけ、ということから、この行動は「盗蜜」と呼ばれます。たとえ盗人呼ばわりされても、桜の樹の枝にとまって花をつつくスズメの姿はなんともかわいらしいものです。

スズメの春

スズメの春

スズメにとっての春は、子育てがスタートする重要な季節。桜が咲くころメスは卵を産みはじめ、すべての卵を産むと、抱卵の開始です。

　じっと温めること2週間。卵がかえると、親鳥は今度は毎日ヒナにエサを運び、かいがいしく世話をします。そうしてヒナは巣立ちの日を迎えますが、面倒見のいいスズメの親鳥は、巣立った後もしばらくはエサをとるのが苦手な幼鳥にエサをあげるのです。

　この時期はそんなほほえましい親子をそこかしこで見ることができます。

スズメの春

40

スズメの春　41

巣立ってすぐの子スズメたちは、生まれた巣の近くの町の公園などで過ごします。親鳥はしばらくそこで面倒を見た後、問題がなければ次の子育てに入ります。8月末ごろまでに合わせて2〜3回の子育てを行うカップルもいるほどです。

　その年巣立った子スズメたちは、のどと頬の色はまだ淡く、くちばしの根元も黄色です。見つけたら、驚かせないよう注意深く見守りましょう。

スズメの春 45

スズメの夏

人にとっても過ごしやすい春に続いては、暑い夏が到来。人にとって夏といえば、一般に他の季節に比べて行動的になる季節ですが、スズメたちはどうなのでしょう。ここでは6・7・8月のスズメたちの様子をご紹介します。

スズメの夏　47

梅雨が明け、日本全国が本格的な暑さを迎えるこの時期。親鳥たちにとっては、まだまだ子育てシーズンが続きます。

　人間はというと、近年は爽やかな初夏の印象はほとんどなく、酷暑から逃れるため戸外での活動は避けて屋内にこもりがち。しかし高温と日照に恵まれる夏は、作物も雑草もすくすくと育ち、エサとなる昆虫たちも豊富。寒さが厳しくエサも減少する冬に比べれば、スズメたちにとっては過ごしやすい季節なのかもしれません。とはいえ、暑いは暑い。スズメの集まる公園などでは、水場で水分補給をしたり、大好きな水浴びをしたりする涼しそうなスズメたちの姿が。ぜひ探してみてください。

スズメの夏

スズメの夏　51

日がのぼってしばらく経つと、スズメたちはエサ場に近いお馴染みの場所に集まりだします。そして一日中、獲物を追いかけまわしたり、食べたり、水浴びや砂浴びをしたり、羽づくろいをしたり、仲間同士でやりとりしたり。それぞれの行動をとりながら、何度も離合集散を繰り返しながら過ごすのです。集団行動が基本とはいっても、共同でなにかをするといったことは特にありません。

　そして夕方になると、ねぐら近くに戻り、眠りにつきます。

スズメの夏

スズメの夏

スズメの秋

「黄金色の田んぼにスズメ」は多くの日本人の心に刻まれたイメージでしょう。かつてスズメが害鳥と見なされたのは、農村部での秋の集団行動が大きな理由を占めていました。ここでは9・10・11月のスズメたちの様子をご紹介します。

スズメの秋

晩秋から冬にかけては、町や住宅地で見かけるスズメの数はぐっと少なくなります。すべてが行くわけではありませんが、それでも多くのスズメが農村部などの郊外に移動するからです。町とは反対に、郊外ではさらに大きな群れが見られるようになります。
　この群れの中には、その年生まれの若いスズメも、子育てを終えた親スズメも混ざっています。

スズメの秋

秋から冬にかけてのこの時期、どのスズメにも共通なのが、それまでの古い羽毛が抜け落ちて新羽に替わること。鳥を飼っている方ならよくご存知の「換羽」です。羽がきれいになったスズメたちは、エサを食べて冬に備えます。

スズメの秋　67

スズメの冬

地域によっては寒さが非常に厳しく、スズメたちの個体数も一年を通して最も少なくなる冬。しかし春の繁殖期に向け、この時期を乗り越えなければなりません。ここでは12・1・2月のスズメたちの様子をご紹介します。

秋とは一転、冬になりエサが乏しくなってきた農耕地を後にして、スズメたちの多くは再び町や住宅地へと帰ってきます。

　この時期、群れの状態は、その土地土地の気候などによって異なります。積雪の多くある地方では秋に見られた大きな群れは消え、小回りの利く数十羽から100羽程度の規模になります。

　一方、暖かい地方では真冬でも大きな群れが継続することも。また寒い地方でも、エサ場があるような食べ物に苦労しない場所では、ある程度大きな規模の群れが維持されることもあります。

スズメの冬　73

スズメの冬

寒さは厳しく、エサも少なくなる、試練だらけの冬。スズメたちは一日を無事乗り切るため、とにかくできるだけ食べて体力をつけ、昼も夜も少しでも温かい場所を探して過ごします。しかしこの時期、寒さに耐えるスズメの姿は、皮肉なことに人の目にはとてもかわいらしく映ります。毛をめいっぱい逆立てて空気の層を作り、寒さ対策をしているいわゆる「ふくら雀」状態のスズメは、そのふっくらもこもこ感で大人気。2羽〜数羽で寄り添い合って暖をとる姿に惹かれる人も少なくありません。

　2月ごろになると、スズメたちはつがいになりはじめます。そして巣場所を物色するなど、春からの子育てに向け準備をスタートするのです。

Special Interview

『にっぽんスズメ歳時記 WE ♥ SUZUME!』
写真家・中野さとるさんに聞く

スズメを見守る温かな視線が感じられる写真で、今日も多くの人を魅了する中野さん。スズメを撮りはじめたきっかけ、その世界に惹きこまれていった理由などについてうかがいました。

――スズメを被写体とされたのはいつごろからでしょう。また、そのきっかけは?

スズメを撮りはじめたのは3年前くらいからだったと思います。それまでは普通に犬や猫、景色などを撮ったりしていたのですが、ある日、被写体を探しにふと立ち寄った公園でスズメの群れを見つけたんです。スズメは鳥の中でも地味な印象ですし、どうかなと思いつつもとりあえず観察していたところ、スズメたちのしぐさが面白くて。頭を掻いたり、体を膨らませたり細くしたり、まさに七変化するんですね。それで、これはちょっとやってみようと思って撮りはじめたんです。すると、スズメが非常に社会的な鳥だということがわかってきました。仲間で遊んだりケンカしたり、食べものを取り合ったりする姿が、まるで人間社会の縮図のように見えてきたんです。そこで、スズメたちを被写体にしてドラマのある写真を撮ろうと思いました。

――ほかの鳥と比べて特にスズメに惹かれる理由がありましたらお聞かせください。

絶えず新しい発見があることですかね。群れで行動するスズメはそれぞれ個性があって見かけも性格も全然違うんです。けんかっ早いのや、おっとりしたの、なかには群れが嫌いでいつも少し離れたところにいるのもいます。そばに近づくと怒るスズメもいますね。子連れのお母さんスズメは特にケンカに強いです。そんな発見がまたたまらなく楽しいんです。

――春夏秋冬、どの季節のどんなスズメの姿に惹かれますか?

やっぱり春でしょうか。繁殖の季節なので求愛ダンスや追いかけっこが見られます。そして5月ごろからは親子が増えてくるんです。親スズメを必死に追いかけていく子スズメはたまらなく可愛いです。そのうち群れの顔ぶれもくちばしの黄色い若いスズメにどんどん変わっていきます。まだ子どもですからイタズラしたり血気盛んな姿が見られますね。秋になると、群れで行動するので、慣れ親しんだスズメとはしばしお別れです。そういう意味では、少し寂しい季節です。ただ電柱や電線にたくさんのスズメたちを見ることができますね。

中野さんのお気に入り！写真&コメント その①
「最後まで居残った2羽のスズメと一緒に夕日を眺めました。そのとき撮った夕日を背景にしたスズメたちの写真です」

——撮影されていて自然の厳しさを感じたり、感激したり驚いたりしたことは？

　心配になるのは、やはりスズメの病気や障害です。腫瘍ができたり目が見えなくなったりしているのを見ると、なんとかしてあげたい気持ちになってしまいます。片足の動かないスズメもいました。必死で飛ぶんですけど着地が不安定になったりするんです。自然界ではそうした個体は長生きできないと聞きますが、それでも精一杯生きている感じは強く伝わってきますね。楽しいのは、撮影のときはモデルの御礼にいつもおやつを持っていくんですけど、もう覚えていて、わたしの姿が見えた瞬間に遠くから一斉にふわぁ〜って飛んでくるんです。で、屋根や柵に一列に並んでおとなしく待ってるんですよ。なかには待ちきれずに足元をウロウロして要求してくるのもいますが、それはいつも同じスズメ。やっぱり性格ってあるんですね。そしてパンの切れ端などをもらうと独り占めするためにわざわざ遠くに逃げていきます。スズメは基本的に欲張りなんですね。一方で他のスズメを呼ぶ役割のものもいるようで、決まったスズメがピーピー鳴いて仲間を集めているんです。ほんと面白いです。びっくりしたのは、毎回おやつの前に必ず水浴びをしてくるスズメがいたこと。いつもビショビショになってやって来て、目の前でブルブル犬みたいに水を切っていました。何かの儀式なんですかね。単なる

きれい好きなのかな。ちなみに野生のスズメに食べ物を与えすぎるとそれに甘えて自分で食べ物を探さなくなるので、おやつは最小限にしています。だからけんかも絶えないんですけど。

——**撮影されていて「やった！」と思われる瞬間は？**

見たときにドラマやストーリーが浮かぶような写真が撮れたときはそう思います。スズメ同士見つめあって何かを話していたりする姿は、その写真を見た人に何かを想像させますよね。そういったものです。吹き出しをつけてセリフを入れたくなるような写真といえばわかりやすいでしょうか。見た人がその背景を勝手に想像して楽しめるような瞬間を常に狙っています。

——**使用されている撮影機材について教えてください。**

ごく普通の一眼レフカメラです。馴染みのPENTAXですね。以前はK20Dでしたが、今はK-5。使いやすい中級のカメラです。レンズは頻繁に変えなくてもいい55-300mmを使っています。ただこれはちょっと接写が弱いので、目の前にスズメが来たときは標準レンズを使用します。

——**スズメの撮影をはじめて何か機材で工夫したり、導入したものはありますか？**

200mmのレンズだと中途半端に小さく写るので300mmに変えました。スズメの警戒ゾーンに入らずに撮ることのできるちょうどいいレンズです。カメラは動きの速いスズメを撮るのに露出などの面で性能不足になってきたので一度だけグレードアップしました。シャッター音が静かになり、慣れて近寄ってくるスズメを撮るときに怖がられなくなりましたね。

——**日常的に作品を発表する場とされているインスタグラムのよさ、うれしかったエピソードなどをお聞かせください。**

写真を撮ってそれを誰かに見てもらうということが手軽にできることです。自然に感性の近い人が集まってきてくれるのも魅力ですね。スズメの写真にドラマを与えてそれが見た人の感性とぴったり合ったりするとすごく嬉しいです。そしてなにより嬉しいのは「写真を見ていたらスズメが好きになりました」というコメントをいただいたときですね。

——**インスタグラムのフォロワーに人気のスズメ写真はどのようなものですか。また、それについてのご感想は？**

人気のあるものはやはりふっくらした丸いスズメです。冬はそんなふわふわしたスズメたちが身を寄せ合って座っていたりする可愛い写真が撮れます。でもどちらかと言うと、わたしはスズメたちのドラマを撮りたいですね。仲間同士で追いかけ合ったりけんかをしたり、食べ物を取り合ったり——そうした姿をとらえた写真でまた人気が出てくれると個人的にはうれしいです。

——**近年は温暖化など野鳥をとりまく環境の変化についてもよく指摘されますが、撮影していて気づいたことなどありましたら。**

わたしが住んでいる田園地帯では特に変化などは感じませんが、都市部ではかなりスズメが減っている印象があるようですね。インスタ上でいただくコメントでも「スズメを見かけなくなりました」という声は多いです。ただ、都市部からやってくるのでしょうか、逆に田舎はスズメが増えているような気も

中野さんのお気に入り！写真＆コメント その②
「なんとなくアンニュイな目つきの一羽。いろんな表情をしますがこれは特にお気に入りです」

します。それには都市部での巣の作りにくさやヒートアイランドなどが関係しているのかもしれませんね。

――最後に、読者の方にメッセージを。

スズメの世界に興味を持っていただいてありがとうございます。都会では目にする機会も減ってきているようですが、郊外ではまだまだ元気に暮らしています。そんなスズメたちの姿をこれからも切り取っていきますのでよろしくお願いします。

中野さんのお気に入り！写真＆コメント その③
「居眠りをする子雀です。スズメのヒナは巣から落ちたりカラスや猫に襲われたりと、大きくなれるのはほんの一部だそうです。そんな危険を乗り越えてこんな無防備な姿を見せるほどになれてよかったね、と感じる一枚です」

Profile
クラシックカメラ好き。所有カメラ：リコーオートハーフ、コダックレチナ2C　そのほかのProfile→P96参照
「初めて手にしたカメラは、中学生のころ流星を撮りたくて父親に買ってもらった中古のPENTAX ES2.でした。カメラの知識は全くゼロで露出なども理解しておらず、よくフィルムを無駄にしたりしていましたが、写真で何かを表現したい気持ちは昔からありました。結局は人に見せる機会もなくただの自己満足で終わりましたが。本格的に撮るようになったのは4年くらい前、インスタグラムを知ってからです。馴染みのメーカーPENTAXの一眼レフを手に入れて時間さえあるとカメラをぶら下げて出かけては何でも撮りました。当初は気のおもむくままに撮った写真を載せていて、そろそろ何かにテーマを絞ろうと考えていた矢先に出会ったのがスズメでした。おかげさまでフォロワー数も増え、今日もスズメたちを撮っています」

スズメにまつわる Topics&Essay
WE ♥ SUZUME!

ここではスズメ好きならつい反応してしまうさまざまなグッズや、スズメに注目すると自ずと目に入る＆気になってくる野鳥たちのことがわかる本やCDなどをご紹介。『きょうのスー』でお馴染みのマツダユカさんによるエッセイマンガも！

Various Goods

雀コレクション 和の彩りバージョン
（シャイング）

多くの鳥フィギュアを手がけるクリエイター【星の白金】渡部勝彦氏とのコラボによる繊細なディテールのスズメフィギュア。日本の伝統色で仕上げた全10種はすでに入手は難しいが、再発＆スズメモチーフの新企画に期待！ http://shineg.co.jp/

ふっくら福福すずめ
（奇譚クラブ）

「コップのフチ子」のカプセルトイメーカーが送る、まんまるボディがたまらないスズメフィギュア。首は可動式で360度自由にくるくる。重り入りで軽く揺らすとゆらゆら動く。全7色。http://kitan.jp/

WE ♥ SUZUME!

なんて可愛い とりまんじゅう
(リーメント)

小鳥の中になぜか和菓子がひとつ混ざってる!? 鳥好きの人気を集めたカプセルトイが新たな2種を加え2016年秋に食玩で再登場! 種類はブンチョウ2種、セキセイインコ3種、オカメインコ2種、そしてスズメと焼きまんじゅうの全8種。外から中身がわからない仕様なのでスズメが出るまでLet'sチャレンジ! 同名のLINEクリエイターズスタンプも発売中♪
http://www.re-ment.co.jp/

まるコロ羊毛すずめストラップ
(モリタ)

ハンドメイドマーケット minneで鳥好きの熱い視線を集める羊毛フェルトアーティストのリアル&キュートなストラップ。https://minne.com/morimomorita

フェルトアーティスト モリタさんに聞きました!

Q スズメをはじめ野鳥をモチーフに作品を作られていますが、スズメの「特にここに惹かれる」ポイント(ツボ)は?
A 正面から見ると模様でちょっと渋いのに、小さくてお腹がムクムクで可愛いところ。自分ではなかなか上手に作れませんが、くちばしから頭に向かう境目の部分がとても好きです。

Q スズメを題材にする際に注意している点、製作していて楽しい点、苦労する点などお聞かせください。
A くちばしが小さくなりがちなのと顔が大きくなってしまうときがあるので気をつけています。全体のバランスをとるのが苦手なので毎回苦労していますが、形ができた後の模様入れは大好きなのでいつも楽しんで作っています。

Q 中野さとるさんの写真は以前からご存じだったそうですが、魅力を感じる点は?
A いろいろな表情やしぐさのスズメが見られるのが本当に魅力だと思います!

※ P86〜88に掲載した商品はすべて、店頭等で販売中のものを除き、販売終了の場合がありますのでご了承下さい。販売状況、再版、新商品の情報等は各メーカーのサイト等でご確認下さい。
※ P86〜87に掲載したブラインドボックスでの展開商品(なんて可愛い とりまんじゅう)、カプセルトイ(玩具)商品(雀コレクション 和の彩りバージョン、ふっくら福福すずめ)は、いずれも購入時に中身を選べない仕様となっています。

Various Goods 87

Various Goods

福良雀 -Sparrow-
（マスダユウタロウ）

作家マスダユウタロウのデザインによる紙風船モビール。折りたたみ可能な羽パーツなど立体感と変化に富んだ造形と和紙の質感が魅力。http://kamifusen.tumblr.com/Sparrow

日本野鳥の会×夜長堂手ぬぐい すずめ
（日本野鳥の会）

スズメモチーフの日本野鳥の会オリジナル手ぬぐい。夜長堂ならではのレトロテイストなデザインが魅力。http://www.birdshop.jp/

日本野鳥の会オリジナル おさんぽ鳥マスキングテープ3色セット
（日本野鳥の会）

サイズ別の野鳥イラスト入りマスキングテープ3個セット。15mm幅（およそスズメ大の小鳥）、18mm幅（およそムクドリ大の鳥）、24mm幅（およそキジバト大の鳥）。http://www.birdshop.jp/

スズメグッズいろいろ
（スタッフ私物）

最後に、スズメ♥な本書スタッフの元に自然と集まってきた癒されアイテムのほんの一部をご紹介。左からクリップ、ピアス、ぬいぐるみ♪

WE ♥ SUZUME!

BOOKS & CD

『家族になったスズメのチュン』
（偕成社文庫）
竹田津実 著、岩本久則 絵（偕成社 刊）

ヒナのとき瀕死の状態で拾われ、獣医の竹田津先生の元にやって来たスズメのチュン。元気に成長して森の獣医さん一家の一員となったチュンが、あっけない"退院"の日までに巻き起こした騒動を描くノンフィクション。

『見る読むわかる野鳥図鑑』
箕輪義隆 絵、安西英明 解説（日本野鳥の会 刊）

身近な場所に生息する野鳥を平易かつ的確なコメントとともに紹介する図鑑。よく見られる野鳥とそれに似た種が同ページにレイアウトされ調べやすい。生態や行動の解説もあり、野鳥観察の基礎がつまった一冊。

『原色非実用野鳥おもしろ図鑑』
富士鷹なすび 著（日本野鳥の会 刊）

見た目から生態まで、野鳥の特徴をデフォルメした絵とキャッチーなコメントで紹介したイラスト図鑑。楽しみながら自然と知識が頭に入る。和名はカタカナに加え漢字表記、学名はラテン語表記があるのも興味深い。

『CD声でわかる山野の鳥』
安西英明 解説、上田秀雄 録音・編集（日本野鳥の会 刊）

野鳥に興味を持ち、鳴き声を覚えたいという人にぴったりのCD。さまざまな鳥の声とそれを聞き分けるためのコツ（解説）を収録。同じ鳥でも幾通りもの鳴き方をするので聞き分けは難しいがその一助となる一枚。

Various Goods, BOOKS & CD

WE ♥ SUZUME!

マツダユカ presents

スズメかんさつものがたり

『きょうのスー』をはじめとする作品で鳥たちの姿を生き生きと描くマツダユカさん。まるで鳥の気持ちがわかるみたい!? と思いきや、現実はやはり厳しい……ということがうかがえる描きおろしエッセイマンガが登場です。共感必至!

Profile
神奈川県生まれ、静岡県育ち。武蔵野美術大学視覚伝達デザイン学科卒業。在学中から鳥をモチーフとしてイラストや漫画を数多く制作。作品に『ぢべたぐらし』シリーズ(リブレ出版)、『きょうのスー』シリーズ(双葉社)、『始祖鳥ちゃん』(芳文社)、共作に『ハシビロコウのはっちゃん(ひまわりえほんシリーズ)』(よしだあつこ 作／マツダユカ 絵、鈴木出版) などがある。公式サイト「かどべや」http://matsudayuka.web.fc2.com/

『きょうのスー』
(アクションコミックス)
マツダユカ 著
(双葉社 刊)

スズメのスーとその家族を中心に、カラスやメジロ、キジバトなど日常でよく見かける面々が住宅街を舞台に繰り広げる野鳥ライフ。ひょうひょうとユーモラスな中に自然界のシビアさも感じさせる人気の4コママンガ。作品は「漫画アクション」で好評連載中。

あしたも
また会おうね！

中野さとる（アカウント名：Onakan.s）によるスズメワールド
https://www.instagram.com/onakan_s/

写真　中野さとる（なかの さとる）

インスタグラムにてアカウント名「Onakan.s」で写真を発表。2013年ごろより被写体をスズメ中心とする。インスタグラムフォロワーは2万人超（2016年10月現在）。愛知県在住。
https://www.instagram.com/onakan_s/
https://twitter.com/aerial2009

参考文献

『スズメの大研究　人間にいちばん近い鳥のひみつ（ノンフィクション未知へのとびらシリーズ）』国松俊英 文、関口シュン 絵（PHP研究所 刊）
『わたしのスズメ研究（やさしい科学）』佐野昌男 著（さえら書房 刊）
『スズメ――つかず・はなれず・二千年（岩波科学ライブラリー〈生きもの〉）』三上修 著（岩波書店 刊）
『スズメはなぜ人里が好きなのか』大田眞也 著（弦書房 刊）
『スズメのお宿は街のなか―都市鳥の適応戦略（中公新書）』唐沢孝一 著（中央公論社 刊）
『スズメのなかまたち（みる野鳥記）』日本野鳥の会 編、水谷高英 絵（あすなろ書房 刊）
『家族になったスズメのチュン（偕成社文庫）』竹田津実 著、岩本久則 絵（偕成社 刊）
『ある小さなスズメの記録　人を慰め、愛し、叱った、誇り高きクラレンスの生涯（文春文庫）』クレア・キップス 著、梨木香歩 翻訳（文藝春秋 刊）
『スズメの少子化、カラスのいじめ　身近な鳥の不思議な世界（ソフトバンク新書）』安西英明 著（ソフトバンククリエイティブ 刊）
『古事記歌謡―全訳注（講談社学術文庫）』大久保正 訳注（講談社 刊）
『枕草子（新明解古典シリーズ（4））』桑原博史 監修（三省堂 刊）
『源氏物語（新明解古典シリーズ（5））』桑原博史 監修（三省堂 刊）
『短歌俳句 動物表現辞典』大岡信 監修（遊子館 刊）
『日本史のなかの動物事典』金子浩昌・佐々木清光・小西正泰・千葉徳爾 著（東京堂出版 刊）
『植物と動物の歳時記』五十嵐謙吉 著（八坂書房 刊）

STAFF

企画・編集	ポンプラボ
構成	立花律子（ポンプラボ）
ブックデザイン	大森由美（ニコ）
編集協力	宮沢巧
編集	森哲也（カンゼン）

Special Thanks
公益財団法人日本野鳥の会
「漫画アクション」編集部

にっぽんスズメ歳時記
WE ♥ SUZUME！

発行日	2016年11月 1 日　初版 2022年 4 月27日　第9刷　発行
写　真	中野さとる
発行人	坪井義哉
発行所	株式会社カンゼン 〒101-0021 東京都千代田区外神田2-7-1 開花ビル TEL:03(5295)7723　FAX:03(5295)7725
郵便振替	00150-7-130339
印刷・製本	株式会社シナノ

万一、落丁、乱丁などがありましたら、お取り替え致します。
本書の写真、記事、データの無断転載、複写、放映は、著作権の侵害となり、禁じております。
ⓒSatoru Nakano 2016 Printed in Japan
ISBN978-4-86255-377-5
定価はカバーに表示してあります。
ご意見、ご感想に関しましては、kanso@kanzen.jpまでEメールにてお寄せ下さい。お待ちしております。